709. 2 WAR

City and Islington Sixth Form College
283-309 Goswell Road
London
EC1V 7LA
020 7⁵

KT-426-705

Andy W

Claudia Bauer

Prestel

Munich • Berlin • London • New York

CITY AND ISLINGTON
SIXTH FORM COLLEGE
283 - 309 GOSWELL ROAD

4.99

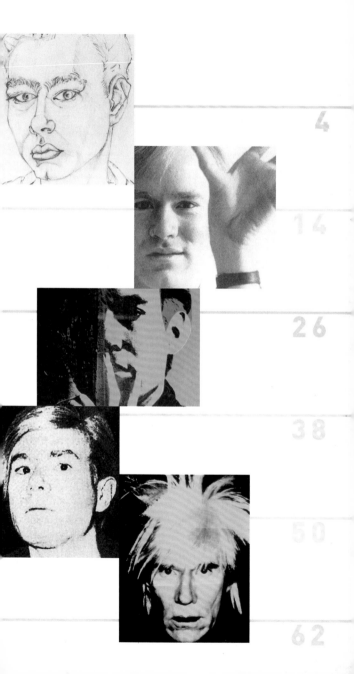

From Pittsburgh to New York

Childhood and adolescence in Pittsburgh _ Studies at the Carnegie Institute of Technology _ Scandal at the Pittsburgh Artists' Union _ The move to New York _ Enthusiasm for Truman Capote

When Andy Warhol died, on February 22, 1987, news of this event flashed around the world. News broadcasts featured it and the next day's newspapers ran front page banner headlines on the death of the man who had "transformed a soup can into a museum-worthy work of art." Andy Warhol was more than an artist: he was a star, who by the end of his life had attained the sort of fame that went far beyond the art world, and who was just as likely to be mentioned in gossip columns as in serious articles on art and culture. He was almost unique in his ability to dissolve the notional boundary between art and commerce and to stylize his own image so that it effectively became an icon. His work is seen as a reflection of the American consumer culture of the 1960s and 1970s. But at the heart of that culture he created a world of his own: the Factory.

Childhood and Adolescence in Pittsburgh _ Throughout his adult life Warhol maintained a strict silence on the subject of his early childhood and adolescence. On the rare occasions when he spoke about them at all, he would make statements that were mutually contradictory. An explanation for this reticence may well lie in the fact that his origins were rather modest by comparison with the sparkle and glamour of his later years. Born Andrew Warhola on August 6, 1928, he was raised in a poor, working-class district of the industrial city of Pittsburgh. His parents, Ondrej and Julia Warhola, were immigrants who had come to America from the Transcarpathian region that is now part of Slovakia. Ondrej Warhola worked for a construction company while his wife sought to increase the family's meager income by taking on odd jobs. The family, in which there were also two older sons, Paul and John, was devout and firmly integrated into the Pittsburgh Ruthenian

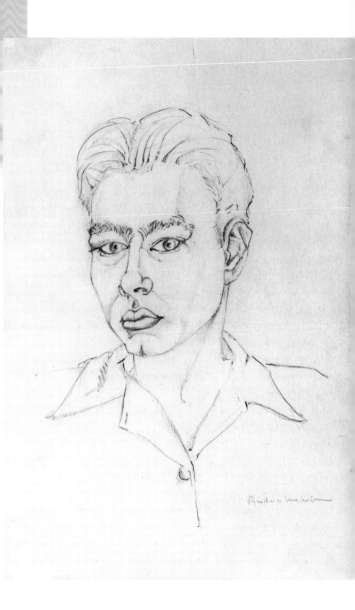

Andy Warhol during his schooldays

Self-Portrait, 1942, pencil on paper, 48.3 × 34 cm, private collection

Julia Warhola with her sons John and Andy, *c* 1931, and Warhol as a student at the Carnegie Institute of Technology

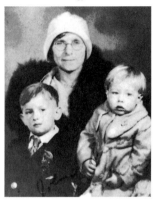

community. In 1934 Andy started at primary school, where he soon proved himself a talented pupil. As a reward, he was allowed to attend the art courses organized for especially gifted children by the Carnegie Museum of Art. But his early years at school were overshadowed by frequent long periods of serious illness, during which he was confined to bed. Julia Warhola would take great pains to tend her youngest son at these times, bringing him comics, coloring books and film magazines, and doing everything possible to encourage his creativity. In 1941 Andy moved on to the local high school and soon began to display great ambition. He devoted his spare time to studying, drawing and his new passion: the cinema. It was at this time that he made the first, still somewhat awkward self-portrait of which we know, showing himself as a bashful youth (p. 5).

Studies at the Carnegie Institute of Technology _ When Ondrej Warhola passed away, in 1942, it was his dying wish that the family's savings be used to finance Andy's studies. While this desire was fulfilled when Andy embarked on a course at the Carnegie Institute of Technology in 1945, these resources were soon exhausted and it became necessary for all three brothers to work hard to support the family. At the Carnegie Institute Andy studied in the Department of Painting and Design, where he soon came into conflict with his teachers on account of his unconventional style and his refusal to adhere to

An anticipation of the later series pictures

Cover of the campus magazine, *Cano*,
November 1948

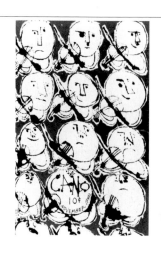

the strictly prescribed themes. At the Institute he made friends with
his fellow student Philip Pearlstein. The two became deeply interested
in the possibility of working as commercial artists—a career that was
coming into prominence in these early years of the post-war economic
boom. Alongside his courses at the Institute, Andy also became in-
volved in the campus magazine, *Cano*, on which he worked as a design-
er. A cover design made towards the end of his time as a student, with
playfully ornamental images of violinists arranged in several rows
around the publication's title, is an early anticipation of his later series
pictures, which were to repeat a single motif a dozen or even a hun-
dred times. During his time at the Carnegie Institute Andy also took
on paid employment, including a job at the Joseph Horne department
store in Pittsburgh, where he worked as assistant to the window dis-
play designer Larry Vollmer. As Warhol later explained, Vollmer
became a sort of role model:

> *"The whole of one summer I had a job at a department store, where I
> had to look through issues of Vogue and Harper's Bazaar for a won-
> derful man called Mr. Vollmer. For that I got around fifty cents an
> hour and my job was to look for 'ideas.' I can't remember if I ever
> found one. Mr. Vollmer was my idol because he came from New
> York and that sounded very exciting."*
> Warhol, The Philosophy of Andy Warhol, 1975

The Broad Gave Me My Face, But I Can Still Pick My Own Nose, 1948/49, tempera on wood fiberboard, 94 × 45.7 cm, Collection of Ethel and Leonard Kessler

In 1947 and again in 1948 Andy and Philip Pearlstein made trips to New York. There, armed with portfolios of drawings, they called on all the editors of magazines in order to find out what openings there might be for commercial artists. The Art Director of *Glamour*, Tina Fredericks, was so taken with Andy's work that she promised to try to get commissions for him if, when he had completed his studies, he decided that he really did want to become a commercial artist.

Scandal at the Pittsburgh Artists' Union _ In the spring of 1949, just as Andy was completing his studies at the Carnegie Institute, he succeeded in having a work nominally accepted for display in the annual exhibition at the Pittsburgh Artists' Union: *The Broad Gave Me My Face, But I Can Still Pick My Own Nose*. Showing a boy drawn in an Expressionist manner and energetically engaged in the activity indicated in the title, this provoked outrage among the members of the exhibition jury. Only a few of them spoke up for Warhol's picture when it was dismissed as both obscene and third-rate, among them the German artist George Grosz, then in American exile. But these were unable to calm the anger of the majority, and Warhol's picture was not included in the exhibition. It nonetheless acquired a certain notoriety,

and Andy was shortly thereafter able to exhibit it in a show held on the Carnegie Institute campus, where it predictably attracted enormous attention.

The move to New York _ Discouraged by the limited opportunities available to them in Pittsburgh, Andy and Philip Pearlstein left their native city in the summer of 1949 in order to try their luck in New York. Together, they rented a small apartment on the Lower East Side, in those days a run-down district. In spite of their own poverty, for both of these newcomers New York was a revelation: it was a center of literary and art life with a vibrant underground culture that attracted visitors and settlers from all over the world. In the early 1950s everyone was talking about Abstract Expressionism and exponents of this type of painting dominated the New York art scene.

Abstract Expressionism _ A movement in art associated above all with New York in the decade or so after the Second World War and which is seen to have had its starting point in the work of the American painter Jackson Pollock. He regarded the painting process as the expression of spontaneous emotions and physical energies, which could be directly transferred to the canvas through a method known as "drip painting." The term "Abstract Expressionism" was used of the work of other artists working in a gesturally expressive manner, albeit with diverse results, such as Willem de Kooning, Franz Kline, Robert Motherwell and Clyfford Still. It has also been used of art after 1945 in Europe.

Enthusiasm for Truman Capote _ Andy became a passionate admirer of the work of the dandyish young writer Truman Capote, who had become a star of the literary world with his novel *Other Voices, Other Rooms*. He did all he could to meet this new 'hero,' but his numerous telephone calls and letters (some of these even enclosing illustrations inspired by Capote's writings) remained unanswered. Despite this initially very negative attitude on the part of Capote, a close friendship was later to develop between the two.

Untitled (Huey Long), 1948/49, ink on paper, 73.7 × 58.4 cm,
Carnegie Museum of Art, Pittsburgh, Gift of Russell G. Twiggs

Warhol and drawing

When an original is not unique

During his time as a student at the Carnegie Institute of Technology, Warhol took a great interest in various reproduction techniques and evolved a method of his own that is characteristic for his early work: the "blotted line" process. This was a variation on the monotype printing technique and produced images that were distinguished by soft and partially broken (or "blotted") lines. The procedure itself is extremely simple: to begin with, a pencil drawing is made on water-resistant paper. These first lines are then drawn over in ink and the resulting ink drawing then pressed against a second, absorbent sheet of paper. The still wet ink produces on the second sheet a reversed and "blotted" print of the original drawing. Warhol seized eagerly on this uncomplicated procedure, not least because it confused the notion of what was and what was not "original." For Warhol, the true original was not the drawing from which the print was made, but the "blotted line" result of this procedure. "Blotted line" images such as *Untitled (Huey Long)*, made while Warhol was still in Pittsburgh, or *Chess Player* are outstanding examples of this early phase of his work. Even at that point Warhol was already taken with the idea that the process of creating his work involved a stage that did not necessarily have to be carried out by him personally, but could just as well be delegated to someone else. The works later produced at the Factory are a logical extension of this approach. In addition to his "blotted line" images, Warhol at the start of his career also made many drawings which can be regarded as autonomous works in the traditional sense, in that they

Chess Player, 1954, ink on paper, 58.1 × 47.6 cm, private collection

Young man, c. 1956, ball-point pen on paper, 42 × 35 cm, private collection

were not intended to serve as the starting point for monotype prints. Of particular importance at this period in his development are the studies for the *Boy Book* dating from 1955 and 1956. These were drawn from life—an unusual approach for Warhol, who was typically to favor photographs as his source material. These blatantly homoerotic portraits of friends and acquaintances (among them there are occasional drawings of penises decorated with ribbons or the imprint of a kiss) were made in ballpoint pen and have the graphic economy found in the "blotted line" images. Together with Warhol's apparent indifference to correcting errors or to the addition of shading, this aspect of his work hints at a stylistic affinity with the drawings of Jean Cocteau or of Henri Matisse. While the *Boy Book* was never published, the drawings so impressed the New York

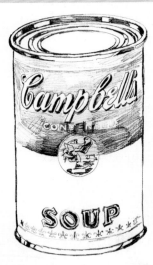

Large Campbell's Soup Can, 1962, pencil on paper, 60 × 45 cm, Hessisches Landesmuseum, Darmstadt, Ströher Collection

gallery owner David Mann that he exhibited them at his Bodley Gallery in 1956.

During the course of the 1950s Warhol gradually lost interest in the "blotted line" technique (which for a time he had even favored in work commissioned for advertising campaigns); but he continued throughout his life making drawings in ballpoint pen, in ink and in pencil. The subjects that he treated during the 1960s as large-scale paintings are also to be found in the form of preparatory or parallel drawings: newspaper headlines and press advertisements, Campbell's soup cans or dollar signs are observed from a variety of viewpoints and recur in numerous variations. Warhol's new drawing style is marked by occasional vigorous hatching or roughly plotted contours and is quite distinct from that of the elegant early work. A whole series of drawings of motifs such as cans of coffee or ketchup bottles, which never became paintings or screen prints, are now seen as studies for ideas that Warhol later rejected. There are also forty pencil drawings for an important work of the early 1970s: the extensive *Mao* series. The drawing of Mao Tse-tung (made from the official portrait that was later to serve as the model for the screen prints) evince subtle

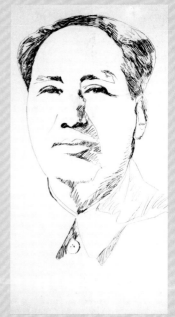

differences from sheet to sheet: variations both in the use of line and in the application of shading testify to Warhol's experiments with the range of effects produced by the same model when observed from several points of view. A comparable approach was to account for the rich chromatic and structural variations to be found in the backgrounds of the later *Mao* screen prints.

Mao, 1973, pencil on paper, 206.4 × 107.3 cm, Collection of Roger I. Davidson, Toronto

From Advertising to Art

Andrew Warhola becomes Andy Warhol _ The first one-man show
_ Vito Giallo and Nathan Gluck become Warhol's assistants _ Pop
Art conquers New York _ Warhol meets Henry Geldzahler _ The
Campbell's Soup Can series captures the mood of the moment _
The making of the *Death and Disaster* pictures

Andrew Warhola becomes Andy Warhol _ On arriving in New
York, armed with a portfolio of drawings from his years in Pittsburgh,
Andy set about looking for work as an illustrator and commercial
artist. As promised, Tina Fredericks of *Glamour* magazine secured his
first commissions for him; and other publications, such as *Seventeen*,
Mademoiselle and *Charm* regularly employed him. Andy took care to
emphasize the image of himself as a "creative type" by calling on the
respective editors dressed always in creased trousers, a roll-neck
sweater and down-at-heel shoes. On one occasion, when he was at the
offices of *Harper's Bazaar,* a cockroach crawled out of his portfolio—a
sure means of getting both sympathy and a commission from the edi-
tor. It was at this time that Andrew Warhola Americanized his name,
working thereafter as Andy Warhol.

In 1950 Philip Pearlstein got married and the two friends from
Pittsburgh went their separate ways. Warhol moved frequently, lived
in communes with people he had met in the New York underground
theatre scene, and eagerly made new contacts. In 1952 Julia Warhola
moved in with her son, who by that time was living in an apartment of
his own. The two of them made a bizarre household with a great many
cats, which had initially been acquired to catch mice but had subse-
quently multiplied out of control. The persistence in Andy's work of
the polarities of the one-off and the series, of the individual and the
crowd, is apparent even here: he called all the cats Sam.

The first one-man show _ 1952 was also the year of Warhol's first
individual exhibition of the work he had done as an artist—as opposed

Every inch an eccentric

Andy Warhol, 1958, in New York

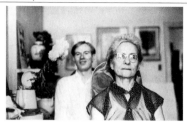

Andy with his mother, Julia Warhola, in their New York apartment, 1958

to his output as an illustrator. "Andy Warhol — Fifteen Drawings Based on the Writings of Truman Capote" took place at the Hugo Gallery. With most art critics still preoccupied with Abstract Expressionism, however, the Warhol show received little attention in the press; nor were any of the exhibited works sold.

In 1953 Warhol and his mother moved to a larger apartment, on Lexington Avenue. Julia Warhola not only took care of the housework but also helped Andy with his own work, coloring in his drawings, inscribing them in her childlike, curlicued handwriting, or even signing them in his name. Warhol changed the way he looked, losing his mildly Bohemian appearance and assuming various much more radical elements: he started wearing white-blond wigs and these, in combination with the thick spectacles prescribed by his optician and his increasingly eccentric clothes, gave him a decidedly original appearance.

Vito Giallo and Nathan Gluck become Andy's assistants _ As Warhol's workload as an illustrator grew and he continued to produce work of his own (some of it being presented as gifts to the editors of magazines), the help he had from his mother was no longer sufficient. So he started inviting friends to help him color in his drawings. In 1955 this led to Vito Giallo and Nathan Gluck being appointed as Warhol's first formally employed assistants. In the same year, in parallel with his work on an advertising campaign for a shoe manufacturer, Warhol produced the portfolio of prints *A La Recherche du Shoe Perdu*, titled in allusion to the novel by Marcel Proust: seventeen playfully *faux-naif* shoe "portraits" neatly inscribed by Julia Warhola and colored in by Warhol's friends were presented to clients in the form of a portfolio. Like his other portfolios and books of this time, this one aroused enormous enthusiasm. The following year Warhol returned to the subject

Shoes in all their variations

A la Recherche du Shoe Perdu, 1955, offset lithograph with watercolor and ink on paper, in a portfolio 66 × 50.8 cm, Estate of Andy Warhol

Elvis Presley (Gold Boot), 1956
Ink, gold leaf, and collage on paper, 50.8 × 35.6 cm, Courtesy The Brant Foundation, Greenwich

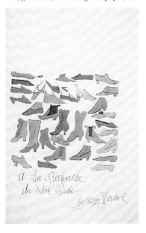

of the shoe in his exhibition at the Bodley Gallery, "The Golden Slipper Show, or Shoes Shoe in America," which was a further series of shoe "portraits," this time each one in gold leaf and representing a celebrity ("Shoes Shoe" was Warhol's own invention, in allusion to the well-known publication *Who's Who*).

Pop Art conquers New York _ In the later 1950s the American art scene was in a state of upheaval. Abstract Expressionism, which had been the dominant trend for around a decade, was gradually ceding to the work of a generation of artists who stood in direct opposition to Jackson Pollock or Willem de Kooning: they were the exponents of Pop Art.

In 1958 Jasper Johns had his first one-man show at the Leo Castelli Gallery. His images of targets, numerals and the American flag provoked a lively critical and public reaction, not least when the Museum of Modern Art (MoMA) acquired six of them. The new era in art was formally inaugurated in the MoMA exhibition that opened not long afterwards: "Sixteen Americans," including work by Jasper Johns and Robert Rauschenberg. Warhol followed these developments with enormous interest and put more effort into planning a definitive break

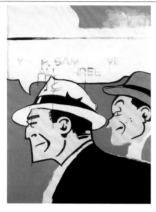

Dick Tracy, 1960, acrylic on canvas, 201 × 114 cm, Collection of Mr. and Mrs. S. I. Newhouse, Jr.

from his involvement with commercial art, further encouraged by the fact that both Johns and Rauschenberg had themselves started out in this field. In following their example he was to draw both on his own professional experience and on the inspiration of the motifs of the new Pop Art.

Pop Art _ An art movement marking the end of Abstract Expressionism. It had its beginnings in Great Britain in 1956 but achieved its greatest influence in the USA. Pop Artists reacted against urban consumer culture and its dissemination through the media by aggrandizing banal objects of everyday use into art objects, reproducing serial images of them or distorting them in a grotesque fashion. In addition to Andy Warhol, the most important Pop Artists were Roy Lichtenstein, Jasper Johns, Robert Rauschenberg, James Rosenquist, Claes Oldenbburg, Robert Indiana, Jim Dine, and Mel Ramos.

Warhol meets Henry Geldzahler _ In 1960 Warhol started to make paintings of advertisements he had found in newspapers and of the comic book heroes of his youth. These new works caught the attention of Ivan Karp, who worked at the Leo Castelli Gallery, which had by

this time become established as a center of the new movement. Through this contact Warhol met Henry Geldzahler, Curator of Twentieth-Century American Art at the Metropolitan Museum of Art in New York, with whom he then became friendly. But Warhol was disappointed in his desire to have his advertisement and comic book pictures shown at the Leo Castelli Gallery. Unlike Karp and Geldzahler, Castelli was not convinced by Warhol's new work. Frustrated at this setback, Warhol turned to new motifs the very next year.

> *"I at once resolved to have done with the comic books because Roy [Lichtenstein] did them so well, and to head off in another direction where I would be the first."*
> Warhol, *POPism—The Warhol Sixties*, 1980

The *Campbell's Soup Can* series captures the mood of the moment _ In his new hunt for ideas, Warhol proceeded quite shamelessly and took every available opportunity to ask the advice of friends and acquaintances. One evening the gallery owner Murial Latow suggested that he concentrate on one thing that he especially liked — money, for example — or on something that would be familiar to everyone, such as cans of soup. Taking her literally, Warhol painted pictures of dollar signs and Coca-Cola bottles, and then a series of

Captured on canvas: a symbol of the "American way of life"

Campbell's Soup Cans, 1962, acrylic on canvas, thirty-two images, each 50.8 × 40.6 cm, Museum of Modern Art, New York, purchase and partial gift of Irving Blum, 1996

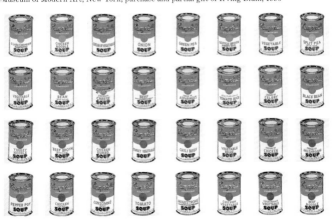

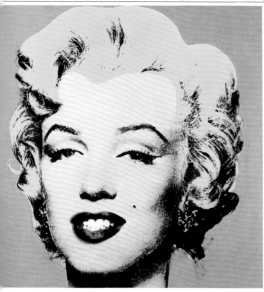

Turquoise Marilyn,
1962, screen print
on acrylic on canvas,
101.6 × 101.6 cm,
Collection of Stefan
T. Elllis

thirty-two cans of Campbell's soup in various flavors. He was later to
explain that the cans of soup had a particular personal meaning for
him: during his impoverished childhood and adolescence his mother
had often been reduced to feeding the family on cans of Campbell's
soup. With the motif of the Campbell's soup can—emotionally indiffer-
ent and rendered without any overt form of artistic "interpretation"
(in its coloring, for example)—Warhol captured the mood of the
moment: like the dollar sign or the Coca-Cola bottle, the soup can was
a symbol of the aspirational "American way of life" and was part of
the instantly recognizable everyday world of almost everyone in the
USA. The Campbell's soup can was, in reality, banal and omnipresent
in the supermarkets; but, through its stereotypical repetition on thir-
ty-two canvases, it suddenly assumed the status of an icon, a literally
"condensed" version of the self-image of America. The Los Angeles
gallery owner Irving Blum was so taken with the *Campbell's Soup
Can* series that he organized an exhibition in August 1962.

On August 5, 1962, a day after the opening of the Los Angeles show,
the world heard of the death of Marilyn Monroe. For Warhol, who since

his childhood had had a particular affection for the stars of the cinema, this event became the spur for the creation of a series of Marilyn portraits. As a model for these, which Warhol would execute as screen prints (a technique he had recently discovered), he used a still from the film *Niagara*. Through the deliberate carelessness of the overlaid planes of garish color making up the star's face, Warhol sought in each of his various Marilyns to convey the sense of artifice that he would retain in other portraits of stars, such as Liz Taylor or Elvis Presley.

The making of the *Death and Disaster* **pictures** _ 1962 was also the year in which Warhol set off in quite a different direction, with the beginnings of his *Death and Disaster* series. Taking his starting point in the ubiquity of press reports of road accidents, he transferred to canvas frightful images obtained from police or newspaper archives. In creating the first of these pictures—*129 Die in Jet (Plane Crash)*—he painted in acrylic, but for the rest he used the screen-printing procedure and then arranged numerous versions of the same motif in several rows:

> *"If you see a terrible image over and over again, it finally loses its capacity to shock."*
>
> Warhol in an interview on the *Death and Disaster* series

News of a catastrophe becomes the inspiration for the *Death and Disaster* series
129 Die in Jet (Plane Crash), 1962, acrylic on canvas, 254 × 183 cm, Museum Ludwig, Cologne
Optical Car Crash, 1962, screen print on acrylic on canvas, 208 × 208.3 cm,
Öffentliche Kunstsammlung, Kunstmuseum, Basel

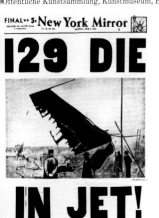

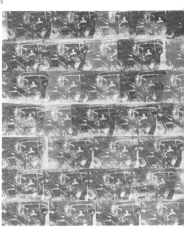

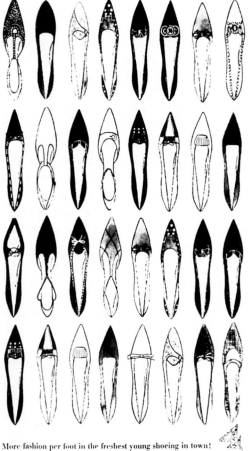

609 Fifth Ave · 450 Fifth Ave · 1552 Broadway · White Plains · Salons at: Abraham & Straus, L. Bamberger, Henri Bendel ·

More fashion per foot in the freshest young shoeing in town!
More deliciously slim shoes for the big glad plaids, the little un-sad
sack suits and mad, flappery furs of this bubbly new season...
More new-personality Millerkins, skylarking Millies and elegant
Ingenues than ever before. In our **450 Collection**, at **I. Miller**

Advertisement for I. Miller in *The New York Times*, 1956

Warhol and advertising

The Art of Selling

Because of the great success that Andy Warhol achieved as one of the most important and celebrated exponents of Pop Art, it is easy to forget that he had his roots in commercial art. It is of course true that Warhol studied Fine Art in Pittsburgh; but, even as a student, he was already deeply fascinated by advertising and its mechanisms. During his short trips to New York he called on the editors of numerous magazines, and he also worked for a time at a Pittsburgh department store with the window display designer Larry Vollmer. After moving to New York, then as now a bastion of the advertising industry, Warhol had little difficulty in obtaining enough commissions to make a living. In spite of his undeniable dependence at this time on paying clients (which necessarily limited his own creative freedom), Warhol nonetheless always retained his own distinctive style, and this ensured that his work was soon in great demand. His ornate, playful drawings and "blotted line" prints were highly regarded among the (mostly female) Art Directors of the great New York magazines, and their enthusiasm ensured a continuous stream of contracts. In 1953 Warhol came to an agreement with Fritzie Miller that she should act as his agent: as a result, he acquired a series of important clients. He obtained the most important contract in his career as a commercial artist in 1955, from the luxury shoe company I. Miller. In collaboration with the company's Art Director, Peter Palazzo, Warhol devised an advertising campaign for *The New York Times*, which once a week printed an I. Miller advertisement designed by Warhol. By this time Warhol's fame as a gifted graphic artist was already so well established that he was given an entirely free hand in creating his designs. The results did not always show specific existing shoes made by the company I Miller; rather, they were

Advertisement for I. Miller in *The New York Times*, 1956

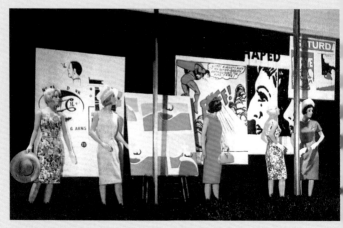

Warhol's window display for Bonwit Teller, New York, April 1961

portraits of the essence of a shoe. Although the shoe manufacturers openly objected to what they saw as an all too free interpretation of the notion of "advertising," the campaign proved unusually successful. In 1956 it won Warhol an Award for Distinctive Merit from the Art Directors' Club of New York. This was to be the first in a series of similar honors that were to make Warhol one of the most highly regarded and best paid commercial artists in the city.

Warhol's involvement with advertising was not limited to the press. Through his first assistant, Nathan Gluck, he occasionally had the chance to design window displays for the New York department store Bonwit Teller. In April 1961 he used one of these to exhibit his first works on a large scale, which had been created under the influence of the provocative output of the Pop Artists Jasper Johns, Robert Rauschenberg and Roy Lichtenstein. Behind the window display models, all dressed in the latest spring fashions, Warhol's *Advertisement*, *Superman*, *Before and After* and *Saturday's Popeye* were hung on a wall, while his *Little King* stood on an easel alongside them. In this context it was immediately apparent how fluid was the dividing line between art and advertising in Warhol's work of this period: in *Advertisement*, which exemplifies this phase of his career, he reworked a series of advertisements that were to be found in any newspaper at this time.

Advertisement, 1960, acrylic on canvas, 182 × 137 cm, Marx Collection, Berlin, on long-term loan to the Städtisches Museum Abteiberg, Mönchengladbach

While already very clearly anticipating his future development, the work of this early period is not yet marked by the sense of sterility and the conscious rejection of industrial mass production that is implicit in his later *Campbell's Soup Can* or *Dollar Sign* series.

In the early 1960s, in order to be taken seriously in the art world, Warhol gradually cut back on his involvement with commercial art, eventually accepting no further commissions. It was only much later, in the mid-1980s, by which time Warhol was an artist of international renown, that he again agreed to market his talents for a number of very lucrative advertising campaigns.

Newspaper advertisements of 1960 used as models for Warhol's *Advertisement* of the same year

The Factory

An old hat factory becomes the new 'in' place for the glitterati _
Jackie (The Week That Was) as a reaction to the Kennedy Assas-
sination _ Warhol's contribution to the New York World's Fair
arouses protest _ A *succès de scandale* with plywood boxes _
Warhol discovers *The Velvet Underground*

An old hat factory becomes the new 'in' place for the glitterati
_ In the late 1950s, still living with his mother in an apartment on
Lexington Avenue, Warhol bought an entire house on the same street
and moved into it with her. Despite having much more space here, he
found that he still did not have enough room for his work, so in June
1963 he rented a studio in a former fire station in East 87th Street.
Though cheap, this was in a very bad state of repair: it had no tele-
phone connection, and there were holes in both the ceiling and the
floor. Warhol also acquired a new assistant, Gerard Malanga, who was
to remain close to him in the following years. In the same summer
Warhol bought a 16 mm movie camera and began to make his first
experimental films.

It was soon apparent that the new studio was too small and too
shabby for Warhol. Within six months he had found a substitute: an old
hat factory near Grand Central Station. Warhol moved into the fifth
floor, thereby acquiring a space of more than 4,300 square feet with a
pay telephone. In allusion to the original function of the building and to
his own more or less "industrial" way of working, he called his new
studio the Factory. This new address soon became a favored meeting
place for the artists, actors, dropouts and photographers that Warhol
knew, as well as for other members of the glitterati. From among the
numerous visitors there gradually emerged a smaller circle of those
who were especially close to Warhol: in addition to Gerard Malanga,
these included Billy Name (Billy Linich), Brigid Berlin (Brigid Polk),
Ondine, and "Baby" Jane Holzer. By the end of 1963 Billy Name had
started to cover the Factory's walls and much of its fittings and furni-
ture with silver foil. Warhol once again altered his appearance to blend

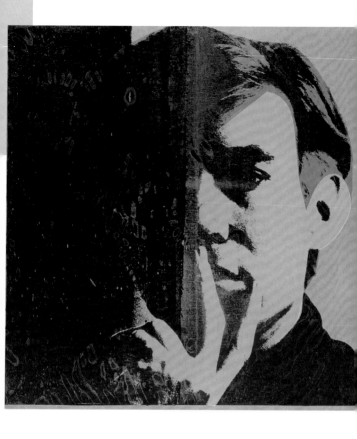

Warhol in a self-portrait from the Silver Factory period

Self-portrait, 1967, screen print on acrylic on canvas, 182.9 × 182.9 cm, Saatchi Collection,
London

Party at the silver-foil-covered Factory, September 1965

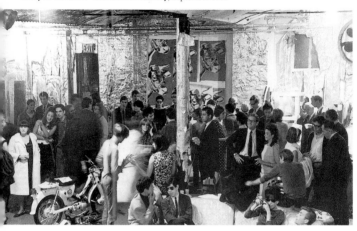

in with that of the underground and literary scene; like the authors
Allen Ginsburg and Jack Kerouac, who were often to be found at the
Factory, he preferred to dress entirely in black. By now he made little
effort to disguise his homosexual inclinations, even if he continued to
keep his own homosexual relationships out of the public eye. It was at
this time that Warhol acquired the nickname Drella—a conflation of
Cinderella and Dracula.

Jackie (The Week That Was) **as a reaction to the Kennedy
Assassination** _ On November 22, 1963, not long after Warhol had
moved into the Factory, the world went into shock: the American
President, John F. Kennedy, was assassinated in Dallas, Texas. As in
the case of his Marilyn portraits, Warhol again reacted immediately
to the news in his work, producing a series of screen print portraits
of the President's widow, of which the most stirring, *Jackie (The Week
That Was)*, showed Jackie Kennedy in sixteen distinct images, both
before the assassination and at her late husband's funeral.

Warhol's contribution to the New York World's Fair arouses protest _
Like Robert Rauschenberg, Roy Lichtenstein and Robert Indiana,
Warhol was invited to contribute a work to the World's Fair that was
due to take place in New York in the summer of 1964. He was allocat-
ed part of the exterior of the New York State Pavilion, designed by

A tribute to the President's widow

Jackie (The Week That Was), 1963, screen print on acrylic on canvas, sixteen panels, each 50.8 × 40.6 cm, Collection of Mrs. Raymond Goetz

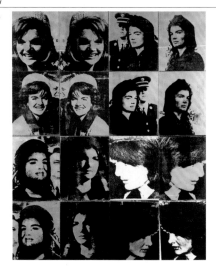

Philip Johnson, and he produced for this a vast screen print of 380 square feet. Called *The Thirteen Most Wanted Men*, it was based on a series of photographs of individuals then being sought by the police. As soon as the work was installed protests flooded in. The depicted criminals were almost entirely of Italian origin and some, in fact, no longer had a price on their heads. Both the Governor of the State of New York and the President of the World's Fair feared being accused of discrimination against an entire ethnic minority, and they demanded that Warhol substitute another work in place of the first.

The "Most Wanted Men" provoke a scandal

Thirteen Most Wanted Men at the New York State Pavilion, 1964, screen print on wood fiber-board, twenty-five panels, each 122 × 122 cm

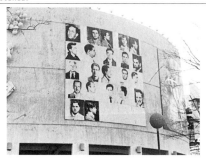

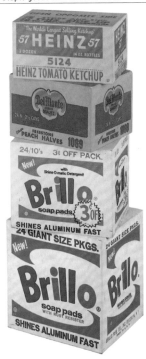

Brillo, Del Monte and Heinz packaging, 1964,
screen print on plywood, private collection

But Warhol would have none of this: instead, he had the screen print painted over in silver, leaving the New York State Pavilion with this monochrome decoration for the duration of the exhibition. Unimpressed by the negative reaction to his *Thirteen Most Wanted Men*, he later produced a series of individual images after each of the "wanted" photographs.

A *succès de scandale* with plywood boxes _ While Warhol's *Death and Disaster* images were rejected in the USA, his first exhibition in Europe, opening at the Ileana Sonnabend gallery in Paris in January 1964, was a great success. Not long afterwards, however, the New York venue that had already exhibited him in 1962, Elinor Ward's Stable Gallery, invited him to show his latest work. This show became a *succès de scandale*: on the evening of the opening Warhol arranged numerous stacks of plywood boxes with their surfaces screen-printed

in precise imitation of packing cases for banal items such as Campbell's Tomato Soup, Kellog's Corn Flakes, Brillo Pads, Del Monte Peach Halves and Heinz Tomato Ketchup. The exhibition attracted hordes of visitors, but Warhol's notion of declaring standard consumer goods to be works of art (thereby extending the idea implicit in his soup can "portraits") served only to irritate, and hardly any sales were made. This commercial failure led to arguments between Warhol and Elinor Ward, and he eventually broke off his agreement to collaborate with her on further exhibitions. This allowed him to fulfill a long-held desire and sign up with Leo Castelli, who by now was all too happy to take him on.

Henry Geldzahler now advised Warhol that, after the somber *Disaster* images and the ambivalent "success" of the Boxes, he should again try his hand at something with a more obvious aesthetic appeal. Warhol took this advice to heart and produced a series of flower screen prints based on a photograph found in a magazine. As expected, these images were very well received, both in America and in Europe—and they sold like hot cakes. When they were shown in Paris Warhol declared that he would henceforth devote himself entirely to film-making. While this soon proved not to be true, it served to further boost sales.

... and flowers achieve commercial success

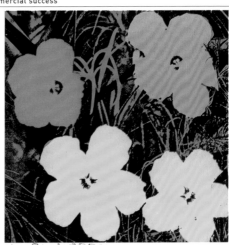

Flowers, 1964, screen print on vinyl on canvas, 61 × 61 cm, Collection of José Mugrabi and Isle of Man Co.

CITY AND ISLINGTON
SIXTH FORM COLLEGE
283 - 309 GOSWELL ROAD

The Velvet Underground at 'The Castle', Hollywood Hills, Los Angeles, 1966, (from left to right) Nico, Andy Warhol, Maureen Tucker, Lou Reed, Sterling Morrison, John Cale

Andy Warhol and Edie Sedgwick at the Factory, 1965

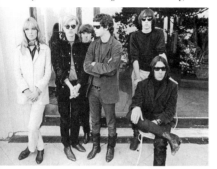

Warhol discovers *The Velvet Underground* _ With Warhol's star in the ascendant the doors of the rich and beautiful were increasingly opened to him and he was at last able to mix in the sort of social circles that had fascinated him as a child. He led a very busy social life, attending parties almost every evening or himself inviting people to his silver Factory. He almost always had with him his movie camera, as well as a Polaroid camera and a portable tape recorder. He used these to document his life, day by day and in particular night by riotous night. From 1965 his inner circle also included the film director Paul Morrissey and the socialite Edie Sedgwick, both of whom were to

The Velvet Underground _ An experimental

group first formed in the early 1960s. The initial line-up consisted of Lou Reed (vocals, guitar), John Cale (bass, viola, keyboard), Sterling Morrison (guitar, bass) and Maureen Tucker (drums). At Warhol's instigation, they then took on the German photographic model Nico (vocals); but, after collaborating on the group's first album, she was forced by Lou Reed to leave. Although *The Velvet Unerground* split up in the early 1970s, the bizarre and sombre sound of songs such as *Venus in Furs* or *Heroin* has had an influence on contemporary music.

appear in many of his films. Among frequent guests at the Factory were members of the New York group, *The Velvet Underground*, with whom Warhol collaborated on a multi-media show, "Expanding Plastic Inevitable" for the discothèque Dom, which had Gerard Malanga and Edie Sedgwick dancing to the group's music while a psychedelic light show played over them. Warhol also designed the cover of the first album to be released by *The Velvet Underground*, in 1967: this featured a banana with its skin unpeeling. But these friendly relations cooled when Warhol's protégée in the group, the singer Nico, was thrown out by Lou Reed. Warhol and the remaining members of the group soon went their separate ways.

Warhol had made a successful début at the Leo Castelli Gallery with a show of his *Flowers* series. In 1966 he put on an even more attention-grabbing exhibition there: on this occasion the walls were covered with a curious, garishly colored Cow wallpaper, while square, helium-filled silver balloons, the *Silver Clouds*, floated about.

> *"And the idea here is to fill them with helium and to let them out of the window, and they'll fly away. And then that's one less object … lying around."*
> Rainer Crone, Andy Warhol, 1970

Cows become wallpaper and helium-filled cushions are a sculptural event

Cow wallpaper, 1966, serigraph on wallpaper, each panel 115.5 × 75.5 cm, private collection

The **Silver Clouds** at the Leo Castelli Gallery, New York, April 1966

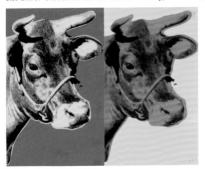

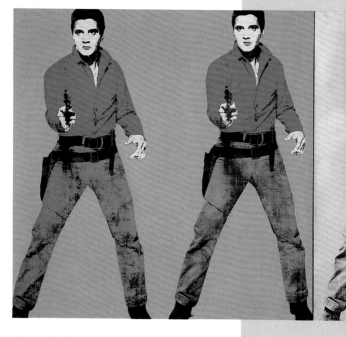

Elvis I and II, 1964, screen print on acrylic on canvas /
screen print on metallic paint on canvas, two panels,
each 208.3 × 208.3 cm, Art Gallery of Toronto, Gift of the
Women's Committee Fund

Warhol and the screen print

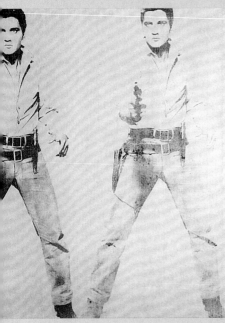

"In fact, anyone can reproduce the design just as well as I can"

Even as a student, Warhol had already mastered the basics of working with a variety of printmaking techniques, while with his early "blotted line" images he had devised and frequently employed a procedure that merged the principles of drawing and printmaking. After the character of his work had altered and he had become committed to the conscious artifice of Pop Art, he seldom painted freehand. The first *Campbell's Soup Can* images, for example, were made with the help of an image projected in magnified form onto the canvas, and it is notable that any too great detail was altogether avoided (the medallion seen at the center of the label on the can should contain an inscription, but in Warhol's version it is empty).

In 1962, not at all long after Warhol had produced his first series of *Campbell's Soup Cans*, he decided to try his hand at screen printing on account of the various advantages that this procedure appeared to

offer: the amount of freehand work involved was minimal (which would make for an overall increase in productivity), and the character of the images produced by this means was very much in keeping with the thematic content of his work: cheap consumer goods.

The principle of screen printing is simple: a fine-meshed fabric—the screen—is stretched taut over a wood or metal frame and is then covered with a special substance that is responsive to light in the manner of photographic paper. Anything whatever can be projected onto the screen. This projection causes those areas not exposed to stiffen and thicken while the rest retain their initial porosity. If the frame is then placed on a piece of canvas and paint is applied to the screen with a roller, a print is produced. In order to produce multicolored images, the process must be repeated for each color. But it is always possible to print onto pre-painted or otherwise pre-treated surfaces.

In screen printing Warhol saw a straightforward and uncomplicated method of making images. The elimination of the artist's own "handwriting" and the mechanical character of the procedure were in keeping with his approach to the "production of an art work." The works he produced by this means were no longer one-off pieces that could without doubt be said to come from the hand of a great master. He was not in the least troubled by the fact that he might have to delegate part of the procedure to assistants (the preparation for each printing session was usually left to technical specialists). He was also perfectly happy with the imponderable oddities and irregularities that arose within a series of prints of the same motif, provoked by congested parts of the screen or by a canvas slipping out of position. Warhol simply had too little patience to worry about that sort of thing, and he was by no means a perfectionist in this respect.

Warhol and his assistants usually screen-printed onto canvases which were laid out on the floor. In the case of monochrome images, Warhol or his assistants would paint the canvases beforehand; in the case of multi-colored screen-printed images, such as the *Marilyn* portraits, the areas corresponding to the hair, the face, the eyes and the mouth were plotted and then filled in with the requisite color. As demand for the screen prints grew, Warhol roped more and more friends and visitors to the Factory into assisting with their production. Later he even delegated the production of entire series of screen prints to commercial

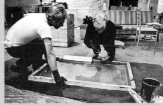
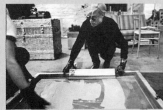

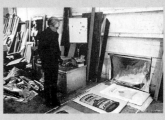

Andy Warhol and Gerard Malanga producing a screen print of one of the Campbell's Soup Can images, 1964/65

printing firms—a move that attracted sharp criticism at the time and that is even now the cause of controversy as to the "value" of a Warhol "original" produced in these circumstances.

It was only in the 1970s that Warhol began to paint in by hand the backgrounds of his screen prints. The canvases of the *Mao* images and of many of the commissioned portraits based on Polaroid photographs are distinguished one from another through the addition of layers of paint of varying thicknesses. Later, as in the case of his *Mick Jagger* series, he screen-printed onto a collage of torn paper, and overlaid his printed images with stylized line drawings. Alternatively, for his portraits of Joseph Beuys, he reworked the image in diamond dust. It was only in what were to prove his last years, when collaborating with the artist Jean-Michel Basquiat, that Warhol returned to his earlier working methods and again painted his motifs directly onto the canvas.

The Attempt on Warhol's Life and its Consequences

The Factory moves to Union Square _ A fateful visit from Valerie Solanas _ Interview magazine appears _ A double première for Warhol's theatre piece Pork _ Nixon's visit to China inspires Warhol's *Mao* series _ The death of Julia Warhola

The Factory moves to Union Square _ The final months of 1967 marked the end of an era: that of the legendary silver Factory. Warhol moved to a new address in Union Square and set up his second Factory there. This one, however, did not so much resemble a place in which to throw parties as an office. A great many of Warhol's former collaborators and permanent guests stayed on board, but the overall atmosphere was much more dignified and respectable, and escapades with drugs and sex were no longer tolerated. Warhol's friendship with Gerard Malanga became brittle, and Frederick Hughes and Jed Johnson appeared on the scene. While Hughes, a Texan, now became Warhol's manager, responsible for establishing contacts with important collectors, Warhol's relationship with Johnson (initially appointed as Malanga's successor) was of a more intimate nature.

A fateful visit from Valerie Solanas _ 1968 opened very promisingly. In the spring of that year the Moderna Museet in Stockholm mounted the first European retrospective of Warhol's work, an event that attracted enormous attention across the international art world. Warhol was also commissioned to design the set for Merce Cunningham's dance piece *Rain Forest* (p. 40), for which he devised an arrangement based on his earlier *Silver Clouds*. His reputation as a serious artist was further strengthened through his participation in that year's "documenta 4" art exhibition in Kassel, Germany. Warhol was now also becoming more deeply involved in film-making, cultivating his connections with high society, and further developing his eccentric lifestyle in the circle of his favoured "superstars." But this

WEATHER
Mostly Sunny, No.
Tomorrow:
Sunny, 80–85.
SUNSET: 8:25 PM
SUNRISE
TOMORROW: 5:26 AM

New York Post

© 1968 New York Post Corporation

LATE CITY
Over the
Counter Stocks

Vol. 167
No. 169

NEW YORK, TUESDAY, JUNE 4, 1968

10 Cents
15c Beyond 50-Mile Zone

ANDY WARHOL FIGHTS FOR LIFE

Marcus Taking Stand

**By MARVIN SMILON
and BARRY CUNNINGHAM**

Ex - Water Commissioner James Marcus was expected to be the government's first witness today in the bribery conspiracy trial that has wrecked his career and saddled the Lindsay Administration with its only major scandal.

His opening testimony follows a dramatic scene in U. S. District Court yesterday when Marcus, 37, changed his plea to guilty in a surprise switch that visibly jolted four of the five other defendants in the alleged $40,000 kickback plot.

The dapper former aide and confidante of the Mayor said he was in no way coerced or promised anything to change his original plea of
Continued on Page 8

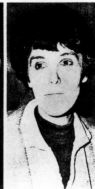

Pop artist-film maker Andy Warhol makes the scene at a recent Long Island discotheque party. Valeria Solanis, who surrendered to police after he was shot and critically wounded, is shown as she was booked last night.

Post Photos by Boyer and Page

By JOSEPH MANCINI
*With JOSEPH FEUREY
and JAY LEVIN*

Pop artist Andy Warhol fought for his life today, after being gunned down in his own studio by a woman who had acted in one of his underground films

The artist - sculptor - filmmaker underwent 5½ hours of surgery performed by a four-man team of doctors at Columbus Hospital late last

*Andy Warhol's Life and Times.
See Jerry Tallmer, Page 3.*

night and was given a "50-50 chance to live."

He remained in critical condition today and his chances for life had not improved.

At 7:30 last night, just three hours and 10 minutes after the shooting, Valeria Solanis, 28, a would-be writer-actress, walked up to a rookie policeman directing traffic in Times Sq and surrendered.

She reached into her trench coat and handed Patrolman William Schmalix, 22, a .32 automatic and a .22 revolver. The .32 had been fired recently, police
Continued on Page 8

Valerie Solanas's attack on Warhol hits the headlines

Front page of the *New York Post* for June 4, 1968

Merce Cunningham and a member of his dance company in Rain Forest, 1968

carefree life was to come to an abrupt halt when, on June 3, Valerie Solanas entered Warhol's Factory.

Without any warning, she pulled out a gun and shot Warhol and a journalist who was also present, before fleeing the scene. While the

Valerie Solanas _ She had been a guest at Warhol's first Factory and had had a small role in one of his lesser-known films, *I, a Man*, made in 1967. By that time she was already well known as a lesbian, as a radical feminist and as leader (and sole member) of the Society for Cutting Up Men, or S.C.U.M. She published the S.C.U.M. Manifesto, in which she urged the total elimination of men. But, unsuccessful in her attempts to attract attention in the underground press, she was constrained to photocopy her declaration and distribute it herself. After her attempt on Warhol's life she underwent psychiatric treatment.

journalist was only lightly wounded, Warhol's injuries had doctors battling for hours to save his life. After a week in intensive care he was finally declared out of danger; and, after a further seven weeks in hospital, he was sent home. Valerie Solanas turned herself in voluntarily at a police station and declared her action part of a campaign of revenge against Warhol for having paid too little attention to her and having degraded women in general in his films.

News of this attempt on Warhol's life went rapidly around the world, incidentally provoking a sudden rise in the sale prices of his work. But the event left its traces, both psychological and physical, on Warhol himself: he now lived in constant fear of new attacks and in 1969 had to undergo a further operation. His upper torso was covered in long scars and required the constant support of a medical corset:

Warhol surrounded by his "creatures"

The "Superstars" at the Factory, 1968:
(from left to right) Nico, Brigid Polk, Louis Walden, Taylor Mead, Ultra Violet, Paul Morrissey, VivA!, International Velvet, an unidentified young man, Ingrid Superstar, Ondine, Tom Baker, Tiger Morse, Billy Name, Andy Warhol

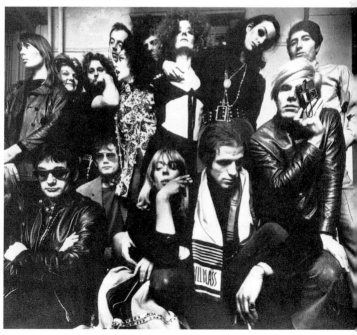

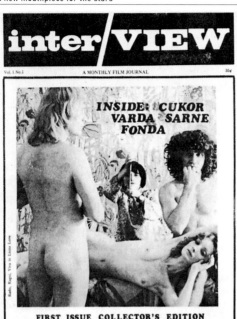

The first issue
of the magazine
inter/VIEW, 1969

"I looked like a dress designed by Dior—no, by Yves Saint Laurent. Seams everywhere."

It was not until September 1968 that Warhol moved back into the Factory. For the rest of that year, everyday life there was quiet; and, except for one further film, he produced no new work. Out of fear of offending the few especially exalted visitors that the Factory still attracted, Warhol placed further restrictions on the lifestyle there, distancing himself further from those circles that had originally done most to create its distinctive atmosphere. Pat Hackett became his personal secretary, among her tasks being to note down Warhol's regular reports on the events of the day and to keep a detailed record of his tape recordings. Vincent Fremont, meanwhile, became Managing Director of the Factory.

Interview **magazine appears** _ The autumn of 1969 saw the publication of the first issue of the magazine *Interview* (originally

inter/VIEW), edited by Warhol, Malanga, Morrissey and John Wilcock. The idea behind Interview came from Warhol's habit of always carrying a tape recorder around in order to record his conversations. But, in addition to interviews, the magazine also published gossip columns and articles on lifestyle; and illustrious friends such as Truman Capote and Bianca Jagger were asked to contribute. This new medium enabled Warhol to establish further contacts among the celebrities of the day; and, both at parties in New York and on his travels in Europe, he was able to extend the range of his acquaintances of this sort, soon counting among them Elizabeth Taylor, Liza Minelli, John Lennon and Yoko Ono, Karl Lagerfeld, Paloma Picasso, and Yves Saint Laurent. In 1970 there was another large Warhol retrospective, this time at the Pasadena Museum of Art. This subsequently came to London and finally opened in New York in April 1971. Warhol also made his first visit to West Germany, for the German première of his film *Trash*, and was enthusiastically received there.

A double première for Warhol's theatre piece *Pork* _ Also in 1970 the New York LaMama Theater and the Roundhouse in London both staged Warhol's first piece for the stage, *Pork*, which was based on tape recordings of his conversations with Brigid Polk. But the piece was not a success and was soon taken off at both venues. In November came the death of Edie Sedgwick: she had become increasingly dependent on drugs and Warhol had broken off contact with her in the late 1960s.

Nixon's visit to China inspires Warhol's *Mao* **series** _ American President Richard Nixon's first official visit to the People's Republic of China focused American attention on this distant part of Asia. Warhol reacted with his usual subtlety to this event and celebrated his "return to painting" (which, strictly speaking, he had never abandoned) with a series of large portraits of Mao Tse-tung. In contrast to his work of the 1960s, he now screen-printed his motifs onto hand-painted backgrounds, and his colors were more subdued. As a model for his portraits (a *Mao* wallpaper was also produced), Warhol chose the official photograph of Mao featured in the Little Red Book, the so-called "Maoist Bible." Henry Geldzahler noted the irony of the fact that it should be "this of all images that would be cheaply produced and then sold at a high price in the capital of the capitalist world." While at

Mao, 1972, screen print on acrylic on canvas, 208.3 × 155 cm, private collection

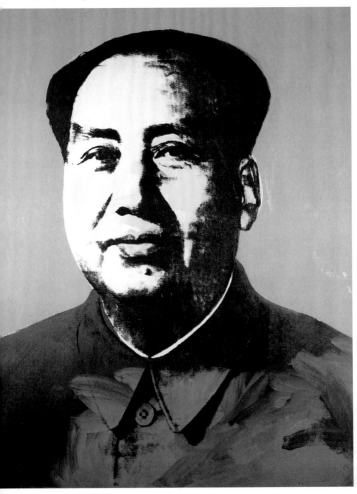

work on his *Mao* series, Warhol received an unusual "portrait commission" from supporters of the Democratic Party candidate in the American Presidential Election campaign of 1972, Senator George McGovern. Rather than portraying McGovern himself, Warhol produced an image of his Republican opponent, the incumbent President Richard Nixon, printed on an especially garish orange background and with the

An artistic contribution to the election campaign

Vote McGovern, 1972, serigraph on paper, 106.7 × 106.7 cm, private collection

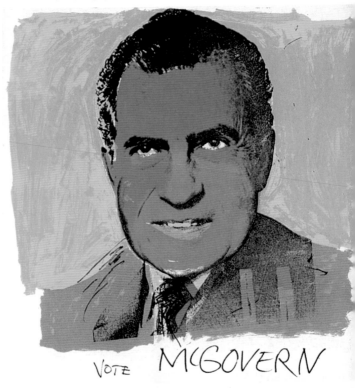

caption "Vote McGovern." But Nixon won the election, and over the next few years Warhol and others who had supported the McGovern campaign (among them the artist Robert Rauschenberg and the writer Norman Mailer) were especially closely investigated by the Inland Revenue Service.

The death of Julia Warhola _ On November 22, 1972 Julia Warhola died. She had had a stroke the previous year and Warhol's brothers had taken her back to live in Pittsburgh. Andy was in Los Angeles when he heard the news of her death. Although happy to pay for her funeral, he did not himself attend the ceremony. Nor did he mention his mother's death to his collaborators at the Factory, who only heard about it by chance and weeks later.

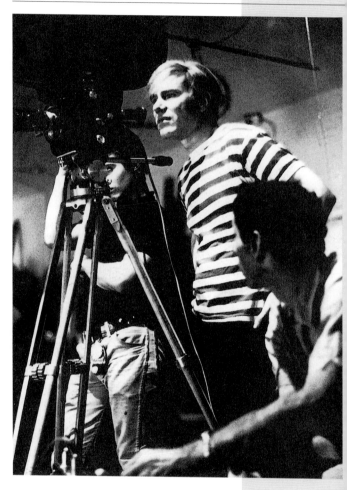

Andy Warhol with Gerard Malanga (left) and
Buddy Wirtschafter (right), 1965

Warhol and film

From loop to screenplay

Even as a child and as an adolescent, Warhol had loved the cinema and its dream factory, Hollywood; and later, when he was a young commercial artist in New York, he had always made a point of seeing the latest films. He got his first movie camera in July 1963, and almost immediately set about making his first films. These appear to have been inspired by the current output of the alternative cinema, which was at that period especially active and was attentively studied by Warhol. His approach was deliberately unprofessional and unsupported by any technical expertise. He filmed friends and visitors to his studio without warning them in advance or posing or instructing them in any way. One of his first films, made in the summer of 1963, was titled simply *Sleep* and showed nothing but the avant-garde poet John Giorno sleeping. The film consisted of eighteen identical sequences, each running for twenty minutes and showing the sleeper from a variety of viewpoints, so that the entire presentation lasted over five hours, a still being shown for a full minute at the end of each segment. A similar structure is to be found in the case of three other films made in 1963: *Haircut*, *Kiss* and *Eat*. With their fixed camera positions and reiterated identical sequences, these films contravene all the conventions of the narrative cinema of

Two frames from the film **Sleep**, 1963

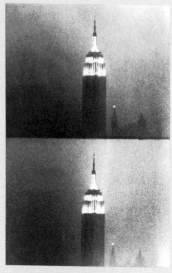

Two frames from the film **Empire**, 1964

Hollywood, but are reminiscent of the serial principle that Warhol employed in the screen prints he was making at the same time. The "actors" featured in Warhol's films were termed "superstars" by him in allusion to the exaggerated language of the commercial film industry and, not least, by the fact that the underground cinema, to which he felt himself to belong, made a point of not cultivating celebrities.

In June 1964 Warhol made further films, among them *Empire*, on which he collaborated with Gerard Malanga and with a leading figure in the underground cinema, John Mekas. What we see is a barely changing, seven-hour-long shot of the Empire State Building, filmed from a nearby office block. In the autumn of 1964 four of Warhol's films were shown at the New York Film Festival, winning him the Independent Film Award. Meanwhile, at the Factory, he made his so-called *Screen Tests*: observed by a fixed, centrally positioned

Still from **Screen Test #2**, 1965 (Mario Montez)

camera, anyone entering the Factory who had the slightest "superstar" potential was required to perform for a few minutes. *Chelsea Girls*, shot in 1966, was the first of Warhol's films to be distributed commercially, and was even scheduled for inclusion at Cannes, although eventually removed from the program before the start of the Festival out of fear of a charge of obscenity. This film consists of several separate episodes without any apparent narrative connection. It was made over a period of several months and, in order to show as much of the shot footage as possible, two reels of film were projected simultaneously, the accompanying sound track swapping back and forth between them. After completing *Chelsea Girls*, Warhol founded Andy Warhol Films, Inc.

For *Lonesome Cowboys*, in 1968, Warhol and his crew traveled to Arizona. Here, however, the candor and permissiveness of the film-makers disturbed the local residents, who eventually became openly hostile. The attention of the FBI was also aroused: noting that "obscene words, expressions and gestures were used throughout the film," its officers had Warhol under close observation for some time. Another film of 1968, *Blue Movie*, in which the Warhol "superstar" Viva! spends the afternoon in bed with Louis Walden, was seized by the police on account of its supposed "indecency."

Among Warhol's subsequent masterpieces of cinema were *Flesh* (1968), *Trash* (1970) and *Heat* (1972), all of these being made in a much more professional fashion and properly directed, by Paul Morrisey. All three found distributors in the USA and in Europe and also proved commercially successful. The last film, *Andy Warhol's Bad*, was made in 1976. In all, Warhol made over sixty films.

Ivy Nicholson performing for a Screen Test

'I want my machinery to vanish'

The Factory moves a third time _ The making of *Ladies and Gentleman* and *Mick Jagger* _ A boom in the commissioned portrait business _ Collaboration with Jean-Michel Basquiat and Francesco Clemente _ Warhol dies after a gall bladder operation

The Factory moves a third time _ In 1973 and 1974 Warhol spent a lot of time in Italy where he was shooting *Andy Warhol's Frankenstein* and *Andy Warhol's Dracula*. In Rome he and his crew stayed with the film director Roman Polanski, whose villa soon became the latest 'in' place for the city's own glitterati. During this period Warhol was even offered a small speaking part in an Elizabeth Taylor's movie, *The Driver's Seat*. In August 1974 the Factory moved for a third time, though on this occasion only a few buildings down the street. The new location offered more space in addition to proper offices, a conference room, and a substantial dining room. At the same time Warhol bought a house on East 66th Street and moved out of his old house on Lexington Avenue. All the activity carried out at the Factory now took place under the auspices of Andy Warhol Enterprises, Inc., a company that Warhol had in fact formally registered in 1957, while still working as a commercial artist. One of the principal duties of his collaborators was now to seek out wealthy patrons for the production of commissioned portraits, which had become one of Warhol's most important sources of income.

The making of *Ladies and Gentleman* and *Mick Jagger* _ In 1975 Warhol reworked a collection of photographs of homosexuals and transvestites to produce his series *Ladies and Gentleman*. In recognition of his contribution to the understanding of homosexuality, he received an award from the New York Popular Culture Association, but the series was not exhibited in the USA. Also dating from this year is the ten-image series *Mick Jagger*, where for the first time he screen-printed on to a collage of torn paper. In 1975 Warhol was also

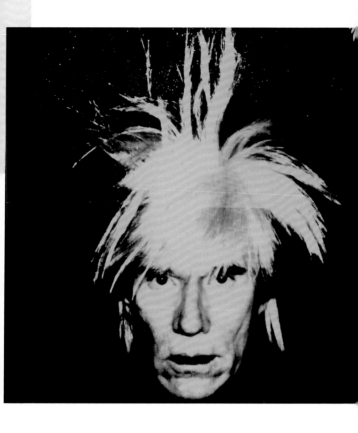

Warhol a year before his death

Self-portrait (detail), 1986. Screen print on acrylic on canvas, nine images, each 58 × 56 cm.
Stuttgart, Froehlich Collection

Ladies and Gentleman (detail), 1975. Screen print on acrylic on canvas, nine images, each 35.6 × 27.9 cm. Estate of Andy Warhol

Mick Jagger (detail), 1975. Screen print on paper on a collage of paper and acetate (foil), ten images, each 127 × 94 cm. Vienna, Museum moderner Kunst, Stiftung Ludwig

 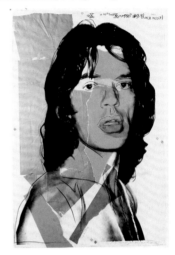

invited to attend a dinner given at the White House in honour of the visiting Shah of Persia. His pronouncements of sympathy for the Shah and his wife (who had spent lavishly in acquiring a collection of contemporary art), as also his occasional contact with Imelda Marcos, provoked sharp criticism of Warhol from the political left. Warhol's essential lack of interest in politics is above all demonstrated in the fact that, while in Germany in 1976, he made a portrait of Willy Brandt and yet later, at the request of Joseph Beuys, who had become a friend, agreed to design an electoral campaign poster for the Green Party. As for the *Hammer and Sickle* images on which he embarked in 1977: of these he simply said that the symbol of the Communist Party appealed to him aesthetically, giving no 'deeper' meaning for this choice of motif.

Spring 1977 saw the opening in Manhattan of the legendary discothèque Studio 54, which soon attained cult status, for VIPs of every sort becoming *the* place in which to see and be seen. Warhol, who was there almost every evening, consorted with both big and little stars and keenly collected portrait commissions. In 1978 he made his first

A new interpretation of the symbol of the Communist Party

Hammer and Sickle, 1977. Screen print
on acrylic on canvas, 182.9 × 218.4 cm.
Estate of Andy Warhol

Piss Paintings, later exhibited as the *Oxidations* series, in which he
realized an idea he had long entertained. These large abstract pictures
were made by covering each canvas with metal dust suspended in a
synthetic acrylic binding agent, on to which Warhol and his assistants
then urinated while the 'paint' was still wet. Equally abstract was the
extensive series of *Shadows*, variously coloured screen-printed ver-
sions of Warhol's own photograph of a shadow.

A boom in the commissioned portrait business _ In the later
1970s a number of important collectors, such as the German Erich
Marx or the London advertising mogul Charles Saatchi, started col-
lecting Warhol's work on a large scale, with the result that his prices in
general rose. By this time Warhol and his Factory had fully perfected
the art of obtaining portrait commissions. Potential customers were
ensnared and invited to lunch at the Factory. For the photo session

An unconventional procedure issues in abstract images

Oxidation Painting, 1978. Mixed media on metallic paint on canvas, 198 × 519.5 cm.
Private collection

that should in theory follow, the model was heavily made up, not only in order to mask lines, but also to exaggerate the 'flattening' effect of flash photography — also a characteristic of the screen prints. As the market value of Warhol's work increased he received ever more portrait commissions.

With his 1979 series *Reversals* and *Retrospectives*, Warhol returned to some of his images of the 1960s. His *Marilyns*, *Automobile Accidents* or *Campbell's Soup Cans* now appeared as negative prints on canvases painted either in glowing colour or in plain black and white. At the same time new motifs appeared in his work, such as those found in the *Skulls*, the *Dollar Signs* or the *Guns* and *Knives* series. In 1981 he produced the series *Myths*, in which he took as his subjects American icons such as Superman, Mickey Mouse or Uncle Sam.

While on a trip to Germany in 1982 Warhol met the film director Rainer Werner Fassbinder and agreed to design a poster for his film *Querelle*. In 1983, in collaboration with the Zurich art dealer Bruno Bischofberger, he devised the exhibition 'Paintings for Children', in which pictures of animals, clowns, aeroplanes, boats and police cars, made especially for this purpose, were hung sufficiently low so that children could look at them without undue effort. Between 1983 and 1984 part of the Factory, mainly that housing the editorial staff of

The singer of the group Blondie as a Warhol icon

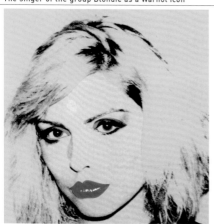

Debbie Harry, 1980. Screen print on acrylic on canvas, 101.6 × 101.6 cm. London, Anthony d'Offay Gallery

The images of Warhol's 'old age' were freer in character

$, 1981. Screen print on vinyl on canvas, 228.6 × 177.8 cm. Collection of José Mugrabi

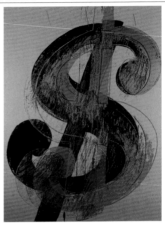

Interview magazine, moved into another recent acquisition of Warhol's: the old Edison electricity works near the Empire State Building.

Collaboration with Jean-Michel Basquiat and Francesco Clemente _ Around the late 1970s and early 1980s a new generation of artists emerged in New York with Julian Schnabel, Eric Fischl, Francesco Clemente, Keith Haring and Jean-Michel Basquiat among its leading figures: in contrast to the exponents of Pop Art, these favoured emphatically gestural brushwork, and their output had a marked affinity with graffiti and other forms of street art. Warhol became especially close to Jean-Michel Basquiat and introduced him to

Jean-Michel Basquiat (1960–1988) _ The son of Puerto Rican and Haitian parents, Basquiat was raised in a petit bourgeois Brooklyn environment. While he was still very young his work, combining motifs from contemporary urban graffiti and black African tradition, had a phenomenal success in the art world. He became a protégé of Henry Geldzahler and Bruno Bischofberger, and a friend of Warhol and Francesco Clemente, and he sometimes worked with both of these. Basquiat broke with Warhol in 1985 and died of a drug overdose in 1988.

Jean-Michel Basquiat, Francesco Clemente and Andy Warhol, *Alba's Breakfast*, 1984.
Mixed media on paper affixed to canvas, 118 × 152 cm. Collection of Bruno and Christina
Bischofberger

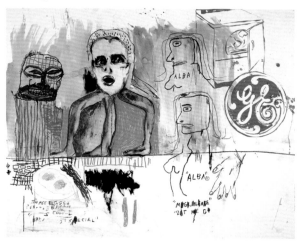

his circle of friends. Working together, the two artists produced the so-
called *Collaboration Works*. Francesco Clemente also contributed to
some of these.

Although there had been an earlier attempt to present a television
show with Warhol, this had not proved a success. In 1986, however,
Andy Warhol's Fifteen Minutes appeared on MTV, its title an allusion
to Warhol's much-quoted statement that in the future 'everyone will
be famous for fifteen minutes'. Predictably, the show featured celebri-
ties from the worlds of art, entertainment and fashion.

Warhol dies after a gall bladder operation _ The last opening of
a Warhol exhibition to be attended by the artist himself took place in
Milan in January 1987 and presented his reinterpretation of Leonardo
da Vinci's *Last Supper*, one of a series of such 'reworkings' of celebrat-
ed pictures by Leonardo, Botticelli, Edvard Munch and others. For
some time he had been suffering from severe bilious attacks, these
eventually forcing him to cancel business meetings and turn down invi-
tations. On the advice of his doctor he was admitted to New York Hos-
pital on 20 February 1987 for a routine operation, even though he had
developed a real phobia of hospitals since his stay in one following the

attempt on his life in 1968. The operation went well, but there subsequently arose a number of never fully explained complications, and as a result of these Warhol died, when both his heart and his lungs stopped functioning on the morning of 22 February. He was buried in Pittsburgh, in a ceremony attended only by family members and close friends, although around 2000 guests were invited to his memorial service at Saint Patrick's Cathedral in New York on 1 April. According to his will, his substantial fortune, further increased through the sale of the extensive possessions he had amassed in a sort of collector's mania, was to be used to establish a foundation (The Andy Warhol Foundation for the Visual Arts) committed to the support of cultural activities.

> '*At the end of my days, when I die, I want no trace of me to remain. And I want to leave nothing behind ... I want my machinery to vanish,*'
>
> Warhol, The Philosophy of Andy Warhol, 1975

Warhol reworks Leonardo's masterpiece

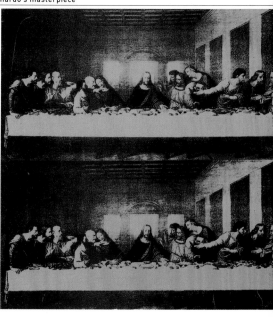

Last Supper. Black / Orange, 1986.
Screen print on acrylic on canvas, 100.1 × 100.1 cm.
Collection of José Mugrabi

The Philosophy
of Andy Warhol

A Harvest/HBJ Book

Cover of **The Philosophy of Andy Warhol**, published in 1975

Warhol's Books

From A to B and back again — the world through Warhol's eyes

Warhol had been involved in one way or another with books since his successful beginnings in New York as a commercial artist. His first ventures into publishing were, however, not books of the sort produced by publishers and then marketed, but primarily portfolios published in limited editions and only in some cases properly bound. The first of these were *Love is a Pink Cake*, a series of twenty-five illustrations of famous love stories, and *A is an Alphabet*, a portfolio with twenty-six of Warhol's elegant 'blotted line' images. Both of these were produced in 1953 and each set of images was accompanied by texts provided by Ralph T. Ward (also known as 'Corkie'), a close friend of Warhol's at this time. Other such portfolios were to follow, among them *25 Cats Named Sam and One Blue Pussy* (1954), an eighteen-page book with portraits of Warhol's cats, *A la Recherche du Shoe Perdu*, *In the Bottom of My Garden* (both of 1955), *A Gold Book* (1957) and *Wild Raspberries* (1959), a satirical cookbook devised in collaboration with Suzie Frankfurt and based on an early-nineteenth-century original. These portfolios and books were generally presented to clients in the press and in advertising.

Covers of **Love is a Pink Cake**, 1953, and of **A Gold Book**, 1957

Andy Warhol with
a: A Novel, 1968

In 1967 Warhol published his first real books: *Screen Tests: A Diary* (Kulchur Press) and *Andy Warhol's Index Book* (Random House), this last introduced by an interview with Andy Warhol and including numerous black-and-white photographs of the legendary Factory. A year later Grove Press brought out *a: A Novel*, a transcription of Warhol's twenty-four-hour-long recorded conversation with Ondine. This publication was dismissed by the critics as 'vulgar'. In 1970 the same publisher brought out the screenplay for Warhol's film of 1968, *Blue Movie*.

In 1975 Harcourt, Brace & Jovanovich published *The Philosophy of Andy Warhol (From A to B and Back Again)*. This time the text was based on Pat Hackett's transcription of tape recordings and recorded telephone conversations and was an extensive collection of Warhol's philosophical musings on such universal themes as love, fame, money and beauty. Unlike *a: A Novel*, *The Philosophy* was enormously successful and was rapidly acclaimed for its reflection of the spirit of the age, even being honoured with an article on the front page of *New York Magazine*. In 1977, under the imprint 'Andy Warhol Books', Grosset & Dunlap published the volume of photographs *Andy Warhol's Exposures*. Along with a good deal of tittle-tattle, this was a collection of Warhol's snapshots of the celebrities he had encountered on his nocturnal wanderings through New York. As it did not achieve the sort of success for which the publishers were hoping, this remained Grosset & Dunlap's only 'Andy Warhol Book'.

The volume of 1980 published by Harcourt, Brace & Jovanovich, *POPism — The Warhol Sixties,* presented Warhol's memoirs of that decade: these were based on notebook entries and taped fragments, these again being assembled and edited by Pat Hackett. In the volume of 1985, *America* (Harper & Row), Warhol offered a selection of the photographs he had taken on his travels. It was at a book signing at the famous New York bookshop Rizzoli that Warhol was again attacked — fortunately, on this occasion in a less violent fashion — by one of his 'fans': a woman pulled off his wig in front of the assembled crowd and escaped with it in a car waiting outside. Very shortly before his sudden death, Warhol put together a photographic chronicle of his debauched life as a party-goer: *Andy Warhol's Party Book* (Crown) was published posthumously by Pat Hackett. She was also responsible for undertaking the enormous project of editing the list of notes on telephone conversations that Warhol had given her every day. This was published in 1989, by Warner Books, as *The Andy Warhol Diaries.*

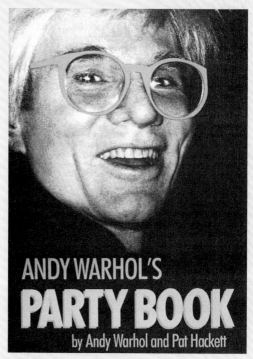

Cover of
Andy Warhol's Party
Book, 1988

Where can Warhol's works be seen?

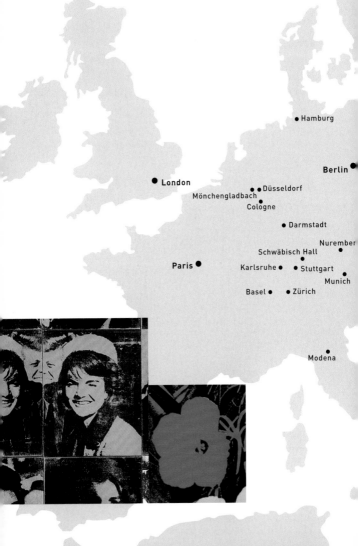

- Hamburg
- **Berlin**
- London
- Mönchengladbach
- Düsseldorf
- Cologne
- Darmstadt
- Nuremberg
- Schwäbisch Hall
- **Paris**
- Karlsruhe
- Stuttgart
- Munich
- Basel
- Zürich
- Modena

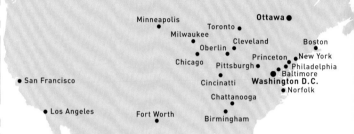

Stockholm •

Minneapolis •
Toronto •
Milwaukee •
Oberlin •
Cleveland •
Ottawa •
Boston •
Chicago •
Pittsburgh •
Princeton •
New York •
Philadelphia
• San Francisco
Cincinatti •
Baltimore
Washington D.C.
Norfolk •
Chattanooga •
• Los Angeles
Fort Worth •
Birmingham •

North America

Vienna •

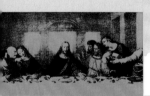

Australia

Canberra •

The following museums all have one or more works by Andy Warhol:

Baltimore, Maryland
The Baltimore Museum of Art
10 Art Museum Drive
www.artbma.org

Basle
Öffentliche Kunstsammlung Basel
Kunstmuseum
Sankt-Alban-Graben 16
www.virtuell.kunstmuseumbasel.ch

Fondation Beyeler
Baselstrasse 101
Basel/Riehen
www.beyeler.com

Berlin
Staatliche Musen zu Berlin –
Preussischer Kulturbesitz
Hamburger Bahnhof,
Museum für Gegenwart
Invalidenstrasse 50–51
www.smb.spk-berlin.de

Birmingham, Alabama
Birmingham Museum of Art
2000 8th Avenue North
www.artsbma.org

Boston, Massachusetts
Museum of Fine Arts
465 Huntington Avenue
www.mfa.org

Canberra
National Gallery of Australia
Parkes Place, Parkes ACT 2600
www.nga.gov.au

Chattanooga, Tennessee
Hunter Museum of American Art
10 Bluff View
www.huntermuseum.org

Chicago, Illinois
The Art Institute of Chicago
111 South Michigan Avenue
www.artic.edu

Cincinnati, Ohio
Cincinnati Art Museum
953 Eden Park Drive
www.cincinnatiartmuseum.org

Cleveland, Ohio
The Cleveland Museum of Art
11150 East Boulevard
www.clevelandart.org

Cologne
Museum Ludwig
Bischofsgartenstrasse 1
www.museum-ludwig.de

Darmstadt
Hessisches Landesmuseum
Friedensplatz 1
www.hlmd.de

Düsseldorf
Kunstsammlung Nordrhein-Westfalen
K20 Kunstsammlung am Grabbeplatz
Grabbeplatz 5
www.kunstsammlung.de

Fort Worth, Texas
The Modern Art Museum
of Fort Worth
3200 Darnell Street
www.themodern.org

Hamburg
Hamburger Kunsthalle
Glockengiesserwall
www.hamburger-kunsthalle.de

Karlsruhe
museum für neue kunst
Lorenzstrasse 9
www.mnk.zkm.de

London
Saatchi Gallery
County Hall
Belvedere Road, Southbank
www.saatchi-gallery.co.uk

Tate Modern
Bankside
www.tate.org.uk

Los Angeles
The Getty Center
1200 Getty Center Drive
www.getty.edu

Museum of Contemporary Art
250 South Grand Avenue
www.moca.org

Minneapolis, Minnesota
Walker Art Center
725 Vineland Place
www.walkerart.org

Modena
Galleria Civica di Modena
Corso Canalgrande 103
www.commune.modena.it/galleria

Mönchengladbach
Städtisches Museum Abteiberg
Abteistrasse 27
www.museumabteiberg.de

Munich
Bayerische Staatsgemäldesammlungen
Sammlung moderne Kunst
Pinakothek der Moderne
Barer Strasse 40
www.pinakothek-der-moderne.de

Städtische Galerie im Lenbachhaus
Luisenstrasse 33
www.lenbachhaus.de

New York
The Metropolitan Museum of Art
1000 Fifth Avenue at 82nd Street
www.metmuseum.org

The Museum of Modern Art
11 W 53rd Street
www.moma.org

Solomon R. Guggenheim Museum
1071 5th Avenue at 89th Street
www.guggenheim.org

Whitney Museum of American Art
945 Madison Avenue
www.whitney.org

Norfolk, Virginia
Chrysler Museum of Art
245 West Olney Road
(at Mowbray Arch)
www.chrysler.org

Nuremberg
Neues Museum
Luitpoldstrasse 5
www.nmn.de

Oberlin, Ohio
The Allen Memorial Art Museum
Oberlin College
87 North Main Street
www.oberlin.edu/allenart

Ottawa, Ontario
National Gallery of Canada
380 Sussex Drive
www.national.gallery.ca

Paris
Musée National d'Art Moderne
Centre Georges Pompidou
19 Rue du Renard
www.centrepompidou.fr

Pittsburgh, Pennsylvania
Andy Warhol Museum
117 Sandusky Street
www.warhol.org

Carnegie Museum of Art
4400 Frobes Avenue
www.cmoa.org

Princeton, New Jersey
Princeton University Art Museum
Princeton University
www.Princeton.edu/artmuseum

San Francisco, California
Fine Arts Museum of San Francisco
34th Avenue and Clement Street
www.thinker.org

Schwäbisch Hall
Kunsthalle Würth
Lange Strasse 35
www.wuerth.com

Stockholm
Moderna Museet
Skeppsholmen 103
www.modernamuseet.se

Stuttgart
Staatsgalerie Stuttgart
Konrad-Adenauer-Strasse 30–32
www.staatsgalerie.de

Toronto, Ontario
Art Gallery of Ontario
317 Dundas Street West
www.ago.net

Washington, D.C.
National Gallery of Art
Constitution Avenue between 3rd
and 9th Streets NW
www.nga.gov

National Portrait Gallery
750 9th Street NW, Ste 8300
www.npg.si.edu

Smithsonian American Art Museum
8th and G Street NW
www.AmericanArt.si.edu

Vienna
Museum moderner Kunst
Stiftung Ludwig Wien (MUMOK)
Im Museumsquartier
Museumsplatz 1
www.mumok.at

Zurich
Kunsthaus Zürich
Heimplatz 1
www.kunsthaus.ch

CITY AND ISLINGTON
SIXTH FORM COLLEGE
283 - 309 GOSWELL ROAD

More about Warhol:
a selection of books and films
on Warhol and his work

The books on Warhol and those produced by him are no less diverse than his own work as an artist. A brief survey of his own numerous publications, which provide an extensive and sometimes amusing insight into his world, is to be found on pp. 59–61.

Among **standard works** on Warhol is the first monograph on the artist: Rainer Crone, Andy Warhol (Stuttgart 1970). Equally important is the catalogue accompanying the large Warhol retrospective at the Museum of Modern Art, New York, published two years after Warhol's death: Kynaston McShine, ed., Andy Warhol. A Retrospective (Munich, etc. 1989). For Warhol's entire artistic output, see the catalogue raisonné currently being prepared by Georg Frei and Neil Printz in collaboration with Kynaston McShine and Robert Rosenblum. So far, one volume has appeared: The Andy Warhol Catalogue Raisonné, vol. 1: Paintings and Sculpture, 1961–1963 (London, etc. 2002).

Further important **exhibition catalogues** are: Pontus Hultén, Kaspar König and Olle Granath, eds., Andy Warhol; Moderna Museet, Stockholm (Stockholm 1968); David Whitney, ed., Andy Warhol: Portraits of the 1970s; Whitney Museum of Art, New York (New York 1979); Jacob Baal-Teshuva, ed., Andy Warhol 1928—1987; Kunsthaus, Vienna (Munich, etc. 1993); and Heiner Bastian, ed., Andy Warhol. Retrospektive; (London 2002). On Warhol, but also on Pop Art in its entirety, see Marco Livingstone, ed., Pop Art; Museum Ludwig, Cologne (Munich, etc. 1992).

There are a great many **biographies** of Andy Warhol. Particularly recommended are the publications of his erstwhile companions: the generously illustrated volume by David Bourdon, Warhol (New York 1995) and the obsessively detailed recounting of gossip and scandal that is Victor Bockris, Andy Warhol (London 2003). A concise account, not only recounting Warhol's life but also presenting his work in terms of its

contemporary context is to be found in Bob Colacello, Holy Terror: Andy Warhol Close up (New York 1999). An unusual form of biography is offered by Lou Reed and John Cale (who, as members of the group *The Velvet Underground*, were regular guests at the Factory in the 1960s) in their Songs for Drella (Sire Records Company for the US 1990), a very personal musical reinterpretation of the life of their former mentor.

A thorough introduction to the legendary **Factory** in its heyday is provided by Nat Finkelstein, "Oh this is fabulous." The Silver Age at the Factory 1964–1967 (Rotterdam 1989), also published as The Factory Years 1964–1967 (New York 1989). A great deal of striking material is to be found in Debra Miller and Billy Name, Stills from the Warhol Films (Munich 1994), Billy Name, All Tomorrow's Parties — Billy Name's Photographs of Andy Warhol's Factory (London, etc. 1997), and Gerard Malanga, Archiving Warhol, An Illustrated History (London 2002).

For those who prefer to go to the **cinema** there are of course Warhol's own films. Also of great interest is Absolut Warhola, a prize-winning documentary of 2001 by Stanislaw Mucha on Warhol's posthumous celebrity in the Slovakian village of Miková from which his parents had emigrated. Valerie Solanas's attempt on Warhol's life in 1968 was the subject of the film made by Mary Harron in 1996: I Shot Andy Warhol. And David Bowie is brilliant as Warhol in Julian Schnabel's film biography of 1996, Basquiat.

Lastly, a book intended for children but which will surely also both entertain and inform older readers: Silvia Neysters and Sabine Söll-Tauchert, Andy Warhol. Paintings for children (Munich 2004).

Andy Warhol: Self-portraits and Portraits of the Artist

Warhol's work is inextricably connected with Andy Warhol the person.
Warhol was almost unique in his capacity to place not only his work but
also himself, as an 'art object', at the centre of attention. While this
achievement is somewhat astonishing in view of his rather introverted
personality, as expressed in a decidedly diffident bearing and a tenden-

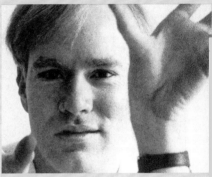

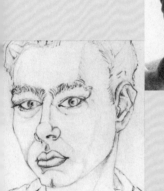

cy to say very little, there nonetheless often lurked a strong element of
cool calculation behind his public appearances and his choice of friends
and acquaintances. The character of his self-portraits is also such as to
suggest the carefully calculated 'staging' of an identity. While genuine
interest in his own appearance and personality may well have motivated
the early self-portraits, his approach altered after he had left home
territory. In New York Warhol soon began to evince a much greater
concern with how he looked: he took care in choosing his clothes, is
said to have had his nose fixed shortly after settling in New York,
and in the early 1950s started wearing a white-blond wig. In front of
the lens of photographer friends such as Duane Michals he adopted

carefully calculated, eccentric poses. His celebrated series of self-portraits made in 1967, consisting of a series of variously coloured screen prints, is also based on a photograph: Warhol appears here as a contemplative observer, his chin supported on two fingers. This self-portrait is at least truly representative in the sense that Warhol was always more of a voyeur than an actor. Always present but never an active protagonist, he precisely registered and examined his environment and was capable of exploiting it to his own advantage. Even Warhol's later self-portraits, some produced as screen prints and others as photographs, set up a sense of mystery. They do not help us to see Warhol as an individual any more clearly; rather, they largely

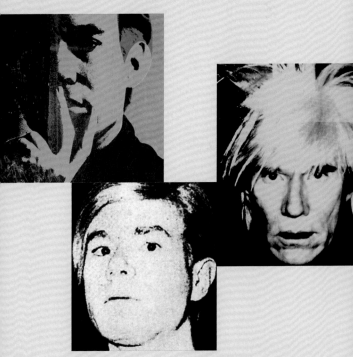

make him seem unreachable and enigmatic. Despite the almost oppressive omnipresence of Warhol's personality in his numerous films, it is telling that he never acted in any of them; this would, of course, have required a 'natural' and spontaneous manner in front of the camera.

Throughout his life Andy Warhol very rarely appeared alone in public. Above all in the 1960s and 1970s, he surrounded himself with a close but ever changing circle of individuals who functioned not only as his assistants, muses or actors, but also accompanied him on his wanderings through the night life of New York. There was lively competition for places in the inner circle of this 'entourage', and Warhol was notorious for allowing his enchantment with someone to give way rapidly to indifference. While some of Warhol's circle used his friendship as a springboard for their own careers, many others were unable to recapture in their later years anything of the sparkle and glamour of the Factory days.

Nathan Gluck Became Warhol's second assistant in 1955. During the late 1950s his contacts and his creativity were to exert a great influence on the future direction of Warhol's career.

'Baby' Jane Holzer A New York socialite and in 1964 *New York Magazine's* 'Girl of the Year'. She appeared in Warhol's first films, among them *Kiss* (1963), and was the first in a long line of his 'superstars'.

Frederick Hughes Born and raised in Houston, Texas, he met Warhol in 1967. As a protégé of the influential Menil family, who were among the greatest art collectors in the USA, he had access to exceptionally good contacts and was appointed President of Andy Warhol Films, Inc., a spin-off of Andy Warhol Enterprises. On Warhol's death, he became executor of the artist's estate.

Jed Johnson Employed by Warhol in 1968 to work at the Factory, he became the artist's lover and remained so until the early 1980s. Johnson assumed directorial control of Warhol's

last film, *Andy Warhol's Bad* (1976). After Warhol's death Johnson chiefly worked as an interior decorator.

Gerard Malanga Employed in 1963, at the age of twenty, as Warhol's assistant, Malanga became one of the artist's most loyal companions, acting in his films and serving as one of the initial co-editors of the magazine *Interview*.

Paul Morrissey Originally a social worker, he joined Warhol's circle in 1965. He worked especially on Warhol's films, serving as director in the case of some of the last of these.

Billy Name Born Billy Linnich, he trained as a hairdresser and lighting technician. He met Warhol in 1960 and became chief photographer at the Factory. It was also Name who covered the walls of the Factory in silver foil. In 1971 he suddenly disappeared from Warhol's life, leaving a note to say merely: 'I'm fine, just gone'.

Ondine Born Bob Olivio, a transvestite with enormous experience of drugs, a regular guest at the Factory from 1963. Played the 'Pope of Greenwich Village' in Warhol's film *Chelsea Girls*.

Brigid Polk Born Brigid Berlin into a wealthy family, she was a rebel with a debauched lifestyle. She met Warhol in 1963 and, from the start, was one of his inner circle. She acted in several of his films and remained loyal to him until his death.

Edie Sedgwick Born Edith Minturn Sedgwick, she met Warhol in 1965. For a number of years he counted her among his closest friends. She acted in many of his films, featured in the *'Exploding Plastic Inevitable'* show, and became a cult figure of the New York of the later 1960s. She died in 1971. A year later there appeared a film biography, *Ciao! Manhattan*.

Viva! Viva! Born Janet Susan Mary Hoffmann, she was a painter before she met Warhol in the mid-1960s. She then became one of the best known of his 'superstars', acting in films such as *Chelsea Girls*, *Lonesome Cowboys* and *Blue Movie*.

© 2004 Prestel Verlag, Munich · Berlin · London · New York
© for the illustrated works by the respective photographers, their heirs and/or other succeeding copyright holders

© for works by Andy Warhol by The Andy Warhol Foundation for the Visual Arts/Artists' Rights Society, New York 2004; TM 2004 Marilyn Monroe, LLC by CMG Worldwide Inc./www.MarilynMonroe.com; 2003 Andy Warhol Foundations/ ANS, NY/TM Licensed by Campbell's Soup Co. All rights reserved

Front cover and inside flap: Andy Warhol, **Self-portrait**, 1986
Back cover: Andy Warhol, **Cow Wallpaper**, 1966 (see p. 33)

Photographic credits: cover and p. 51: Courtesy Sammlung Froehlich, Stuttgart _ p. 5: Courtesy the Andy Warhol Museum, Pittsburgh, Founding Collection, Contribution The Andy Warhol Foundation for the Visual Arts, Inc. _ p. 6, left: Courtesy John Richardson _ p. 6, right: Philip Pearlstein, New York _ pp. 7, 17, left: Philip Pocock _ p. 8: Courtesy Collection Ethel and Leonard Kessler _ p. 10: Courtesy Carnegie Museum of Art, Pittsburgh _ pp. 11, 25, top: Jochen Litt-kemann, Berlin _ pp. 15, 16: Duane Michals, New York _ p. 17, right: Courtesy The Brant Foundation, Greenwich, CT _ p. 18: Jim Strong, Inc., Hempstead, NY _ p. 19: The Museum of Modern Art, New York _ p. 20: Michael Tropea _ p. 21, left © Rheinisches Bildarchiv, Cologne _ p. 21, right: Noel Allum _ p. 24: Archiv Rainer Crone _ pp. 25, 33, left: The Archives of The Andy Warhol Museum, Pitts-burgh, Founding Collection, Contribution The Andy Warhol Foundation for the Visual Arts, Inc. _ p. 27: Saatchi Collection, London _ p. 28: © Fred W. McDar-rah _ pp. 32, 41: Archive of Gerard Malanga _ p. 33, right: Courtesy Leo Castelli Gallery, New York _ pp. 34/35: Powey Chang _ p. 37: Ugo Mulas _ p. 40; James Klosty, with thanks to the Cunningham Dance Foundation _ p. 45: D. James Dee _ p. 46: Billy Name / SLP Stock, New York _ p. 47: The Archives of the Andy Warhol Museum, Pittsburgh _ p. 48, bottom, 49: Billy Name _ p. 52, right: Museum moderner Kunst, Stiftung Ludwig, Vienna _ pp. 52, left, 53: Pillips/ Schwab _ p. 53, bottom: Beh Phillips _ p. 54: Courtesy Anthony d'Offay Gallery, London _ p. 56; Courtesy Galerie Bruno Bischofberger, Zürich _ p. 60; Keystone, Hamburg

The Library of Congress Cataloguing-in-Publication data is available; British Library Cataloguing-in-Publication Data: a catalogue record for this book is available from the British Library; the Deutsche Bibliothek holds a record of this publication in the Deutsche Nationalbibliografie; detailed bibliographical data can be found under: http://dnb.ddd.de

Prestel Verlag, Königinstrasse 9, 80539 Munich
Tel + 49 (89) 38 17 09-0
Fax + 49 (89) 38 17 09 35
Prestel Publishing Ltd., 4 Bloomsbury Place, London WC1A 2QA
Tel + 44 (020) 7323 5004
Fax + 44 (020) 7636 8004
Prestel Publishing, 900 Broadway, Suite 603, New York, NY 10083
Tel + 1 (212) 995 2720
Fax + 1 (212) 995 2733
www.prestel.com

Series concept: **Victoria Salley**
Graphics: **www.lupe.it**, Bolzano, Italy
Edited by **Christopher Wynne**
Translated from the German by **Elizabeth Clegg**, London
Designed and typeset by **zwischenschritt** and **a.visus**, Munich
Originations by **ReproLine mediateam**, Munich
Printed and bound by **Gottesswinter**, Munich

Printed in Germany on acid-free paper
ISBN 3-7913-3198-1